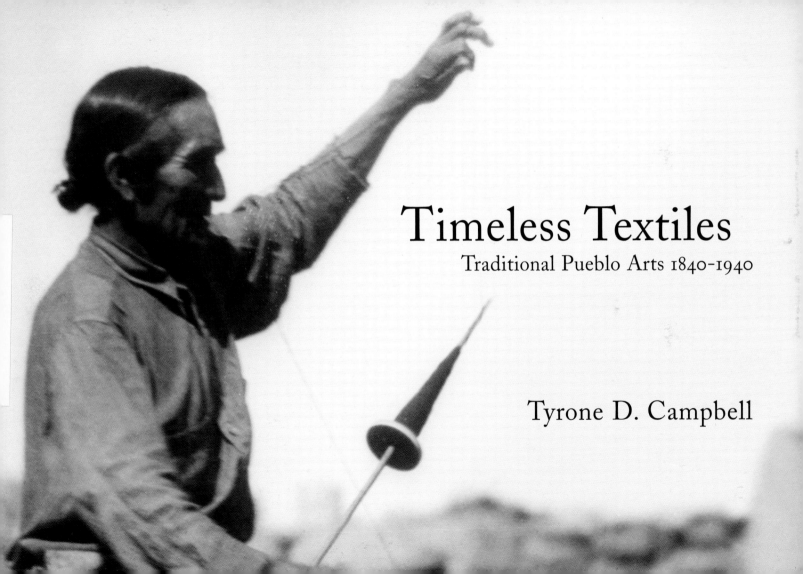

Timeless Textiles
Traditional Pueblo Arts 1840-1940

Tyrone D. Campbell

Copyright 2003
Museum of Indian Arts & Culture

Major support for this catalog was provided by Friends of Indian Art,
a Museum of New Mexico Foundation support group for the
Museum of Indian Arts & Culture.

Guest Curator: Tyrone D. Campbell
Exhibition Managing Director: Duane Anderson
Editor: Jo Ann Baldinger
Photographer: Blair Clark
Catalog Designer: Mike Larkin

Scanning by Gary Mankus Studios
Printing by Roller Printing

ISBN 0-89013-465-0

1		Detail elements comprising the cover design from exhibition
2	3	textiles respectively pictured on (1) page 17 (2) page 16, bottom
4	5 6	(3) page 16, top (4) page 35, right (5) page 10, right (6) page 18, right.

Title page photograph: Hopi Spinner at Hopi, Arizona ca. 1920. Museum of New Mexico #21540

Contents page design detail from exhibition textile pictured on page 10, right.

Contents

Foreword

Over the past few years, growing numbers of woven rain sashes and belts have been appearing at Santa Fe's famed Indian Market, along with crocheted leggings and some very impressive embroidered kilts and mantas—all examples of Pueblo woven textiles. More and more Pueblo women (and a few men) are taking their art to outside markets and, in the process, broadening public awareness of and appreciation for the textile arts that have been produced for over two millennia.

One might think that the Museum of Indian Arts & Culture would have vast collections of historic-period Pueblo textiles. While there are some outstanding examples, the Museum has a total of only 375 items from the 18 pueblos, compared to 900 Navajo weavings of virtually all periods and all types. The reason for this imbalance is simple: Most Pueblo textiles were made not for the tourist trade but for internal use, within the family or the community.

We are fortunate that Charles Brunacini had the foresight to begin collecting Pueblo weavings some thirty years ago, and even more fortunate that he agreed to lend a significant number of them for this exhibition and catalog. Unlike numerous items displayed in museums, these pieces have not been restored, and a great many show evidence of use and wear. In that sense, it is an "honest" exhibit, reflecting the importance of these textiles in the daily lives of their Pueblo owners.

It is my hope that this exhibition and catalog will do much to educate the public about the importance of the textile arts to pre–World War II Pueblo Indians and will provide encouragement to potential buyers of some of the truly outstanding pieces that are being produced today.

Duane Anderson
Director, Museum of Indian Arts & Culture/Laboratory of Anthropology
Santa Fe, New Mexico

Introduction

Pueblo Indian weaving has long been overshadowed by the more glamorous Navajo blanket and rug traditions. The public perception is that Navajos weave and Pueblos make pots. Few are aware that the Pueblos have a very ancient weaving tradition, including spectacular woven sandals and baskets that date back two thousand years to Basketmaker times. The Navajos were comparative latecomers who adopted the Pueblo loom and its technique around AD 1500 and soon developed their own distinctive tradition. Navajos wove for trade to outsiders--at first, blankets for Utes and Plains tribes, and later, rugs for Anglo-American and Hispanic homes.

The Pueblos, in contrast, wove items for their own use, although the early Spanish settlers collected mantas and other textiles as a form of taxation. Kilts and mantas were the proper attire for traditional Pueblo ceremonies and, because of this, became frozen in form in the nineteenth century. It is not considered proper to buy dance materials; a gift exchange is preferred. Such items remain valued heirlooms in Pueblo communities and are passed down within families through the generations.

A good example of such preservation is the Zuni black woven manta with indigo blue embroidered borders. When they needed refurbishing, the mantas were dipped in black dye, and this practice eventually led to the total black appearance of the manta (see page 19, left textile). Many Pueblo textiles show signs of body paint from being worn in ceremonies, as well as darns and other repairs. Some pieces were cut down to serve other purposes when they became too worn (see page 16, right image). Unlike ceremonial kilts and mantas, Pueblo woven belts have long been sold and traded to Navajos and Anglo Americans, a practice that continues today.

Pueblo woven textiles are subtle, but the opposite is true of Pueblo embroidery. Large patterns are executed in the unique Pueblo stitch, which relatively quickly can fill large areas of color in red, orange, black, and green. These embroideries draw viewers' attention across the dance plaza.

Embroidery has taken the place of many ancient weaving techniques and now, in turn, is being usurped by less expensive and time-consuming techniques such as appliqué, ribbons, and even commercially printed cotton cloth. Hand-woven wool or cotton cloth is rarely used as a base for embroidery today. It has been replaced by monk's cloth, a commercial material that resembles hand-woven cloth in appearance and texture. Indian schools in the twentieth century taught girls to embroider in techniques other than the Pueblo stitch and encouraged them to create pillows, aprons, and bureau scarves for their own homes and those of Anglos. Aside from anthropologists, few outsiders have collected Pueblo

textiles. Charles Brunacini is one of those rare individuals. Brunacini was born and raised in Albuquerque, where his parents bought a motel called La Hacienda on Route 66 in 1957. Many Pueblo people stayed there, and the Brunacini family bought pottery from them. Later, when his father was a utilities contractor for the Navajo Nation, Charles accompanied him to the reservation and was impressed by the traditional and timeless lifestyle of the people he met there.

Charles Brunacini began collecting textiles when he was a student at the University of New Mexico. One day in 1972 he visited Tobe Turpen's store on the edge of Albuquerque's Old Town and bought several rugs. As his enthusiasm grew, he began buying regularly from Turpen's store. In 1974 Brunacini opened an Indian art store in Paradise Hills, just west of Albuquerque. He sold a variety of Native arts and crafts and specialized in Navajo jewelry and rugs, but he never sold a Pueblo textile. He obtained the Pueblo material one piece at a time from a number of Southwestern dealers who thought he was foolish because there was no market for such items. Of all the dealers, Brunacini most admires Tyrone Campbell for his breadth of knowledge and his helpfulness.

After the death of his father in 1990, Brunacini left the Indian

Tyrone D. Campbell (left) and Charles C. Brunacini examining Pueblo embroidered shirt pictured on page 39.

art business to take over the family real estate interests. It was also a time when prices for Indian arts were becoming astronomical, and dealing was growing more competitive.

Charles Brunacini continues to admire and collect Pueblo textiles. This exhibition, and the accompanying catalog, make a part of his collection available to Pueblos and non-Pueblos alike, and will, it is hoped, stimulate greater interest in and appreciation for the Pueblo textile arts.

Marian Rodee
Curator Emerita, Maxwell Museum of Anthropology
University of New Mexico, and
Research Associate, Museum of Indian Arts & Culture

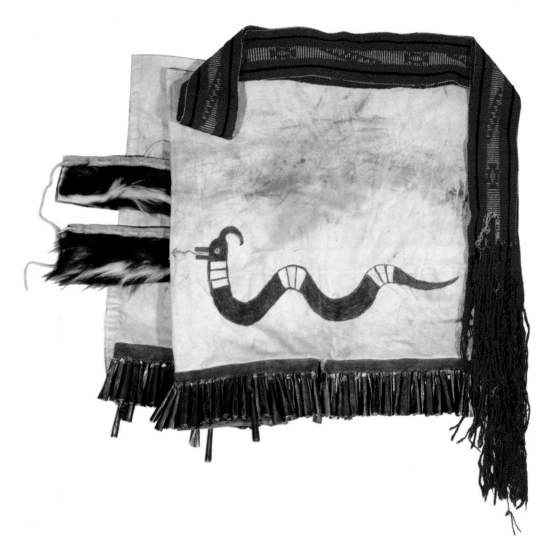

Composition of textiles pictured on pages 21 and 36. The skunk skin anklets are in the Museum of Indian Arts & Culture collection #56189.

The Pueblos are an ancient people whose history goes back into the farthest reaches of time.

Joe S. Sando, *Pueblo Nations*

Evidence of aboriginal peoples inhabiting the American Southwest dates back at least twelve thousand years. By AD 1000, tribal groups known as the Anasazi, the Mogollon, and the Hohokam appeared at sites such as Chaco Canyon in western New Mexico. These so-called Ancestral Pueblo cultures were advanced in the arts of architecture, agriculture, astronomy, weaving, pottery making, religion, and government. Although they mysteriously disappeared around the thirteenth century, by the fifteenth century many of their descendants were well established in villages throughout what is now New Mexico and northern Arizona.

The Ancestral Pueblo people were excellent weavers; plain cotton cloth appeared in the archaeological record by the first century AD. When the earliest Spanish adventurers arrived in the Southwest in the mid-sixteenth century, they were surprised to find the Pueblo people cultivating cotton and finely clothed in colorful and complex-patterned cotton garments. So great was the production of cotton cloth that the Spaniards initially felt no need to produce textiles for themselves. They introduced the endomienda system of taxes and forced labor that kept the Pueblo Indians virtually enslaved until the Pueblo Revolt of 1680. Each Pueblo family was required to furnish great quantities of cotton cloth to the Spanish settlers, a burden that undoubtedly kept the people occupied weaving plain cotton cloth for clothing, to the detriment of the finely designed and colored textiles of the precontact period. The cloth was in the form of mantas--a generic term for rectangular, horizontally woven garments that may be worn as either shoulder blankets or dresses.

Although the colonists eventually acquired and constructed traditional European harness looms, neither the Pueblos nor the Navajos ever adopted them, preferring to go on using their own traditional upright looms. The spinning wheel, similarly, was present during both the Spanish and American periods, but it never replaced the traditional spindle and whorl still used by Native weavers to this day.

Two well-known scholars, Ruth Underhill and Kate Peck Kent, divide the postcontact development of Pueblo textiles into historic periods. Kent defines these as (1) the Spanish period, 1540 to 1848; (2) the Classic period, 1848 to 1880; (3) the Anglo-American period, 1880 to 1920; and (4) the Revival period, 1920 to 1950.[1]

The Spanish period (1540 to 1848) changed Pueblo weaving in several essential ways, the most important being the introduction of sheep into the Southwest. By the mid-seventeenth century, textiles woven exclusively with wool had taken their place alongside the traditional cotton repertoire. Most prominent were blankets, mantas, and women's dresses. Two other important items were introduced by the Spanish: indigo dye, a permanent, rich blue plant dye, and bayeta, a finely worsted woolen cloth manufactured in Manchester, England, and shipped via Spain and Mexico into the Southwest. Bayeta came in a variety of shades of red, from rose to scarlet and burgundy, and provided colors unobtainable from local native plants. It was raveled, retwisted, and woven into

garments beginning about 1840. The greatest amounts of bayeta are found in mantas made by Acoma and Laguna weavers, although it was also used at Zuni and by the Hopis, particularly in "maiden" mantas.

Pueblo weaving reached its artistic heights in the classic period (1840–1880), with beautifully embroidered mantas woven primarily at Acoma and Laguna Pueblos of wool with bayeta embroidery. Scholars are divided on whether it was the Spanish who introduced the art of embroidery to the Pueblos; H. P. Mera, for one, believed it was acquired from Indian weavers in northern Mexico.[2] But there can be no doubt that Pueblo women achieved great skill and beauty in their embroidery during this period.

The Anglo-American period (1880–1920) brought both positive and negative influences. In the early 1880s the railroad arrived in the Southwest, bringing goods that would change Pueblo life forever. Perhaps the foremost of these were synthetic aniline dyes and machine-made Germantown yarns from mills in Pennsylvania. Machine-made clothing and trade blankets woven of both cotton and wool were shipped in large quantities, and an inexpensive version of bayeta called American flannel was also introduced.

So great was the influx and influence of American goods that by the late 1880s weaving had declined markedly at the Pueblo villages closest to the large population centers. By 1900 virtually all the Indian peoples of the Southwest had adopted American-style clothing and replaced hand-woven blankets with commercial trade blankets, such as those woven by the Pendleton Woolen Mills. (The Hopi pueblos of northern Arizona weavers were a notable exception; thanks to their remote location, they were less subjected to external pressure and continued to weave traditional garments.) Germantown yarns, raveled American flannel, and synthetic dyes replaced bayeta and indigo in the years between 1870 and 1900. The Pueblo weaving tradition simply could not compete with these new, much less expensive goods.

The last period considered in the exhibition is that of the Revival, 1920 to 1950. Beginning in the early 1920s American Indian arts and crafts became increasingly popular with collectors, spurred on by heavy promotions by the Fred Harvey Company's Indian Rooms and shops along the Santa Fe Railroad lines. Headquartered in Albuquerque, New Mexico, the Harvey shops specialized in both ancient and contemporary Indian arts and crafts. The Harvey Company's "Indian Detours" took growing numbers of tourists to archaeological sites and Indian pueblos. Major shops selling Native goods opened in New York and Los Angeles, and archaeological and anthropological studies, which had been in full swing since the late 1880s, gained increased publicity in the media.

The Gallup Ceremonial, an important juried event of Indian arts launched in 1921, added to the growing interest in arts and crafts, and the New Mexico Association of Indian Affairs, founded in 1922, encouraged Indian artists through exhibitions. By the early 1930s, the Santa Fe Indian

School was encouraging students in the revival of traditional arts for sale to tourists. But World War II and a continued reliance on commercial fabrics brought the Revival to an end.

Pueblo textiles have never received the historical, financial, or aesthetic attention devoted to Navajo weavings. Although dozens of books have been written on the history and development of Navajo weaving, the bibliography for Pueblo weavings contains only a handful of texts.

Various theories have been proposed to explain this neglect. Pueblo textiles were woven for personal and ceremonial use and therefore were not particularly useful or appealing to the Anglo-American public. While Navajo weavings had been a commercial enterprise since the early eighteenth century and found favor with the early Anglo traders, few traders tried to create a market for Pueblo weavings because so few were available.

Attempts to create a lucrative market for Pueblo weavers during the Revival phase of 1920 to 1950 were never really successful. A Navajo rug or saddle blanket had a functional and commercial use, but what was one to do with a Pueblo dance kilt? Moreover, Navajo designs are bold, daring, and colorful and can be seen across a room, whereas a Pueblo manta must be viewed close up to appreciate its great technical achievement and subtle beauty.

Another possible reason why Pueblo textiles have not received the critical acceptance they deserve is the conservative nature of the Pueblo people themselves and the primarily abstract designs, which essentially have not changed for the last two thousand years. Navajo designs are powerful, never-ending variations of geometric and pictorial elements, whereas Pueblo designs are quiet and subdued and don't provoke a readily understandable emotional response. The difference between Pueblo and Navajo textiles may be compared to hanging a Rothko painting next to a van Gogh. Both are beautiful, but each requires a very different mind-set to understand and appreciate.

With the exception of a few early anthropologists and collectors in the late 1800s, Pueblo textile arts would have to wait until the mid-twentieth century to find their audience and their rightful place as rare and beautiful art. Despite the valiant efforts of individual artists at various pueblos, the future of Pueblo textile arts remains highly uncertain.

TYPES OF PUEBLO WEAVINGS

During the historic period, blankets, mantas, kilts, sashes, women's dresses, belts, garters and hair ties, shirts, breach cloths, and stockings were produced at all the pueblos. Men were the primary weavers and women did the embroidery, although there were exceptions. What follows is a brief description of the various categories of Pueblo woven textiles as well as some of the techniques employed in their making.

Hopi weaver at Hopi, Arizona. Photograph by Carl N. Werntz, 1901. Museum of New Mexico #37526.

Blankets and serapes were made primarily (but not exclusively) by the Zunis and Hopis. Woven in plain tapestry weave, the majority were fairly coarse, simple striped or banded designs, although the Hopis' so-called moki-style blanket had alternating indigo blue and natural brown stripes overlaid with geometric designs primarily in red and white; small amounts of green and yellow, and later, in the 1880s and 1890s, orange, were also used. Blankets were full-sized; they were worn primarily by men and were also used for bedding. Chief blanket styles, primarily a Navajo type woven longer than wide, were also produced.

A second type of blanket, after the common striped blanket, was the Hopi shoulder blanket. Woven in herringbone twill in natural brown and white checks (later, black and white), these were worn exclusively by men, although small sizes were made as gifts for infant boys. The large sizes died out almost immediately with the advent of machine-made blankets. For a brief period in the early twentieth century, Hopi men wove Navajo-style rugs in an attempt to gain some of the commercial tourist market that the Navajo had so successfully captured; but this attempt did not last.

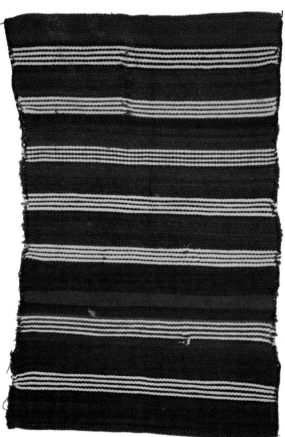

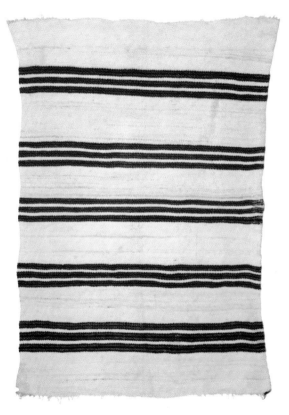

Hopi blanket, 51" x 77", c. 1885–95. Loosely woven in native handspun merino wool in five zones of aniline purple and natural dark brown stripes. A classic example of Hopi striped (or zoned) patterning. Except for those made at Zuni, few Pueblo weavings went beyond these basic design concepts.

Hopi blanket, 40" x 64", c. 1890s. Woven in native handspun wool weft and cotton warp in beautiful natural dark brown wool. This blanket was collected at Second Mesa.

Zuni Pueblo blanket, 50" x 71", late Classic period, c. 1870–75.
Woven in native handspun merino wool warp and weft with
a raveled pink and a raveled red bayeta. Many Zuni blankets
were warped fringed.

Hopi infant boy's blanket, 23" x 25", c. first half of 20th century.
Woven in handspun cotton and handspun wool. Tradition has it that
these herringbone twilled blankets were given to newborn boys by
paternal relatives within a few weeks of birth or when the boy began to
wear clothes. Collected at Second Mesa.

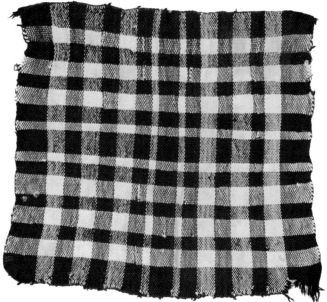

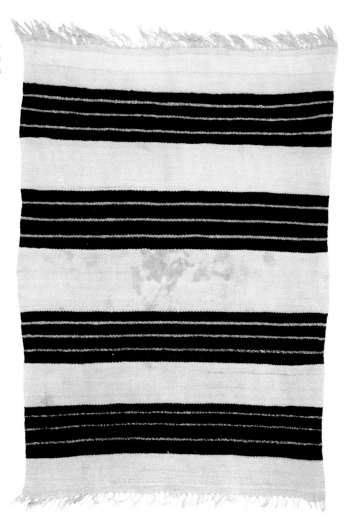

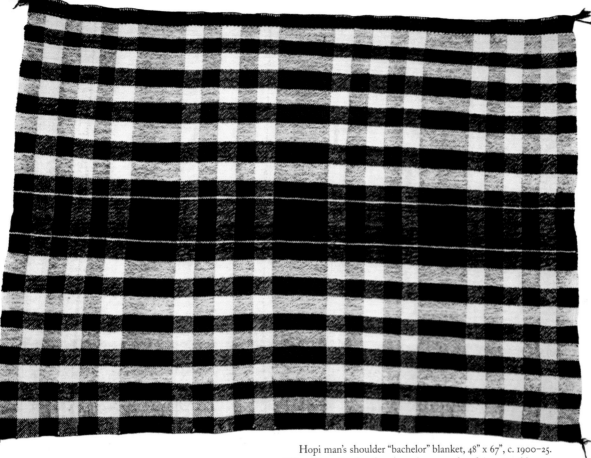

Hopi man's shoulder "bachelor" blanket, 48" x 67", c. 1900–25.
Woven in native handspun wool warp and weft in natural brown
and white. These plaid herringbone shoulder blankets in twill
weaves were replaced by American-style clothing in the late
19th and early 20th centuries.

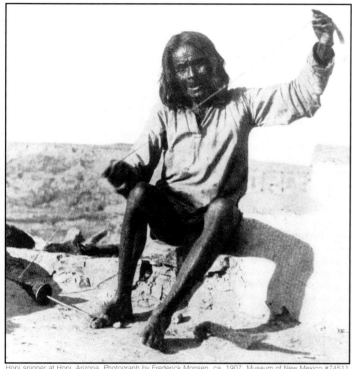

Hopi spinner at Hopi, Arizona. Photograph by Frederick Monsen, ca. 1907. Museum of New Mexico #74511.

Mantas were woven with all cotton, all wool, or a combination of the two. The early wool mantas (c. 1800–1880) had a natural brown wool center done in a diagonal twill weave, with end panels dyed in indigo blue woven with a diamond twill technique. After about 1880 to 1885, the centers and ends were over-dyed black. The Zuni type is distinguishable from the Hopi by the inclusion of three raised ridges (referred to as "hills and valleys") above both end panels. Mantas from the northern Rio Grande pueblos are simpler than those of the Hopis and Zunis.

A second type of wool manta, and perhaps the most artistically appealing, was also woven with diagonal twill centers but embroidered with geometric designs in bayeta during the Classic period, circa 1848 to 1880. These rare examples were embroidered primarily in raveled red bayeta and handspun indigo; occasionally, small amounts of green and yellow were used. Acoma and Laguna were the main sources, although Zuni produced a few mantas with bayeta red stripes in the end panels. At Zuni, wool mantas were woven with natural brown diagonal twill centers and diamond twill end panels, but the ends were embroidered with indigo blue wool in delicate floral patterns. These were produced primarily during the Classic period and disappeared around 1870.

Another type, the Hopi "maiden" manta, was woven with a diagonal twill white cotton center and broad end bands in raveled red bayeta (in diagonal twill) and handspun indigo blue done in diamond twill. After

Acoma Pueblo manta, 42" x 52", pre-1865.
Woven in handspun cotton warp and weft,
embroidered in indigo blue and green wool
and raveled bayeta. The two red and black
figures in the field are stylized eagles.

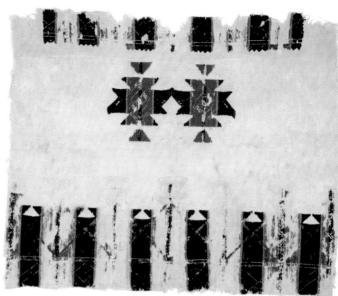

Pueblo manta (probably Zuni), 34" x 50", c. 1850–60.
Woven in native handspun wool with indigo blue end bands
done in diamond twill and natural brown center woven in an
unusual diagonal twill, alternating brown and blue threads.

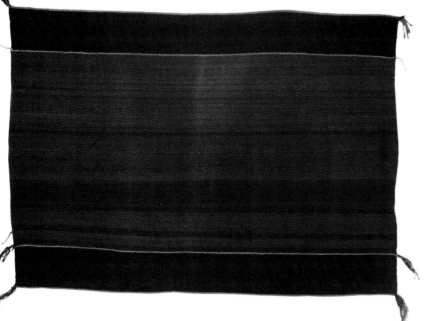

1880 to 1885, bayeta was replaced with a synthetic red-dyed raveled American flannel, and the blue handspun was replaced by a black dye. A very few examples were woven with a wool center instead of the traditional cotton.

The Hopis also made all-white, plain-weave cotton mantas known as wedding mantas. The bride receives a smaller inner shoulder manta as well as a larger one decorated with cornhusk tassels at one end, wrapped in black and white checkered wool. The outfit is completed by an all-white sash with a long fringe, called a rain sash. These all-white cotton mantas are found in numerous archaeological sites throughout the Southwest and were used in the past, as they are today, as burial shrouds. These are undoubtedly one of the oldest forms of mantas.

The last type of manta is the white cotton manta embroidered across both ends with colored wool yarns. These exceptional textiles were made at virtually all the Pueblo villages from the Rio Grande to the Hopi mesas, with the great majority coming from Zuni and Hopi. The bottom end of the manta is embroidered in black and green wool with various triangular vignettes of colored symbols such as butterflies, kachina masks, rain, clouds, and sunflowers. A few rare Hopi examples have kachina masks and sun, rain, cloud, and lightning symbols in the field. Since the introduction of Germantown yarns in the early 1880s, most embroidery is done with these yarns, although some of the Rio Grande pueblos used colored cloth appliqué for the designs in the early twentieth century. It was not uncommon for other pueblos to acquire plain-weave cotton mantas from Hopi or Zuni and embroider the designs themselves.

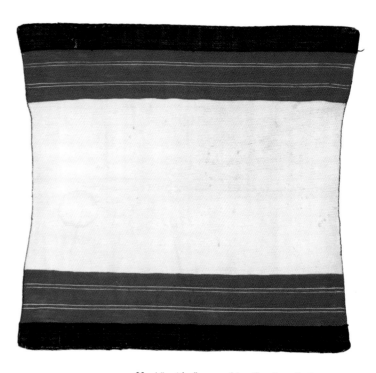

Hopi "maiden" manta (shawl), 42" x 42", circa 1880. Woven in commercial and handspun cotton, three-ply indigo dyed wool and raveled two-ply red (American flannel). Traditionally worn by women in kachina dances.

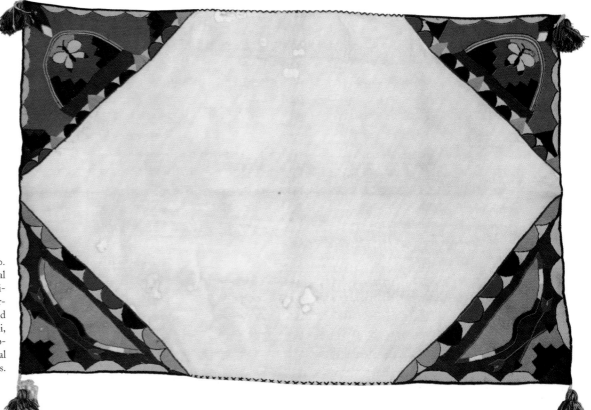

Pueblo manta, 49" x 75", c. 1920–40. Woven with handspun and commercial cotton and commercial wool embroidery. The embroidery in the four corners is a very unusual treatment and may suggest an origin other than Hopi, possibly one of the Rio Grande pueblos. The embroidery is a traditional Pueblo stitch. Note the crossed arrows.

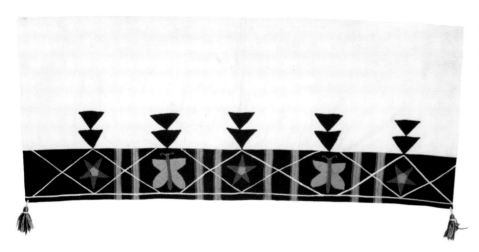

Rio Grande pueblo manta, 24" x 62", c. 1940–50. Commercial wool embroidery on muslin, with appliquéd black cloth. Note the absence of an embroidered top line design, a result of being cut down for use as a kilt.

Rio Grande pueblo manta, 28" x 58", c. 1920–30. Cloth appliquéd on muslin with commercial wool embroidery in a buttonhole stitch with two butterflies and three unknown symbols. This manta has been cut down to form a kilt.

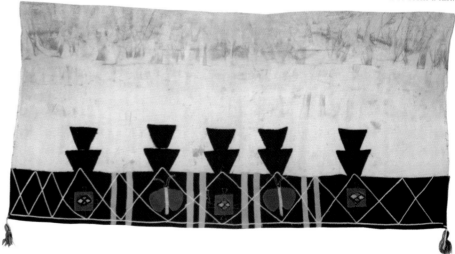

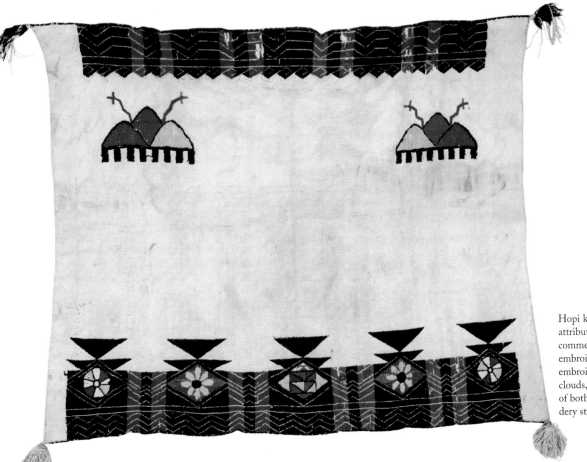

Hopi kachina manta, 45" x 54", c. 1895–1905, attributed to Ahbah of Sichomovi. Woven of commercial cotton with Germantown wool embroidery. Rarely is the white cotton field embroidered with symbols–in this case rain, clouds, and lightning. Butterflies are a symbol of both woman and beauty. Pueblo embroidery stitch.

Hopi/Zuni kachina manta, 39" x 57", c. 1930–40.
Woven with commercial cotton and embroidered with
commercial plied wool. The purpose of the pictorial
vignettes (usually three to five in number) is lost in
time. The two end symbols are rain and clouds; the but-
terfly is a symbol of beauty. Pueblo embroidery stitch.

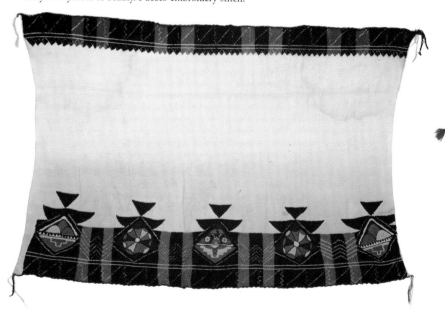

Acoma Pueblo manta, 46" x 38", c. 1850.
Woven in dark brown handspun wool with
indigo blue handspun and raveled two-ply red
bayeta embroidered ends. A textbook example
of Classic period Acoma weaving and embroidery.

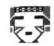

Zuni Pueblo manta, 38" x 50", c. 1840–60. Woven in native handspun; center in a diagonal twill weave, indigo dyed over natural brown. The end bands are embroidered with five floral motifs in indigo blue on blue. Note the three ridges (hills and valleys) above each end panel, typical of Zuni mantas.

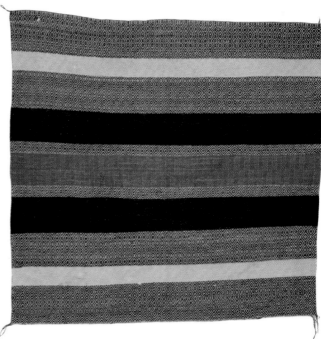

Pueblo shoulder blanket or manta, 44" x 47", c. 1880–85. Woven in native handspun wool with indigo dye and aniline orange in eleven horizontal panels with five different types of twill weaves--a sampler tour-de-force.

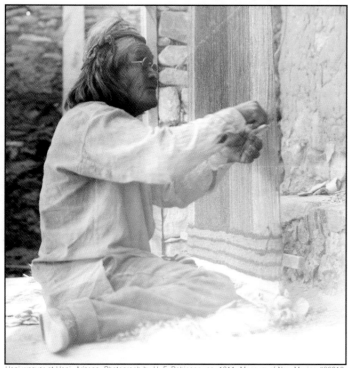

Hopi weaver at Hopi, Arizona. Photograph by H. F. Robinson, ca. 1911. Museum of New Mexico #36912.

Aside from early kilts that were painted on hide, there are two main types of dance kilts: those woven of cotton and embroidered with wool, and those with painted designs on commercial cloth. The woven cotton kilts are done primarily but not exclusively by the Hopis; the painted kilts are produced mostly by the Rio Grande pueblos, except for the Hopi Snake Dance kilts.

The cotton kilts are embroidered vertically on the sides in a black wool triangle-and-hook motif, with symbols in green and red wool. The embroidery extends only about three-quarters of the way up both sides. White spaces are left open, as in the mantas, to create a negative pattern. According to oral tradition, the terraced designs represent clouds and the vertical red lines rain, although the true symbolism has probably been lost in time.

The painted kilts are usually of white commercial canvas sackcloth with painted designs of horned avanyu (water serpents), either alone or in facing pairs. A sun symbol is another common design motif. These commercial cloth kilts came into use around 1890. The earlier ones were painted with mineral paints (yellow ochre being a color favored at Santo Domingo Pueblo), the later ones with commercial paints. All have handmade tin cones attached across one end, which tinkle when the wearer dances. They are worn like an apron, tied at the waist.

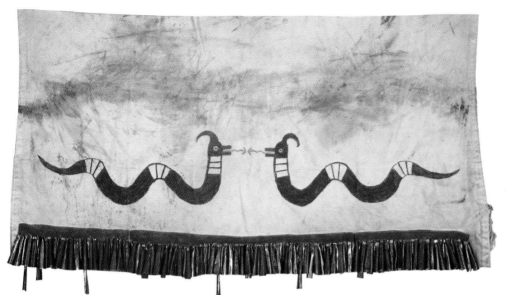

Pueblo Buffalo dance kilt, 22" x 46", c. 1920–40.
Two facing avanyu (water serpents) painted on
canvas, with tin cones and a leather strip bot-
tom. Worn by male dancers.

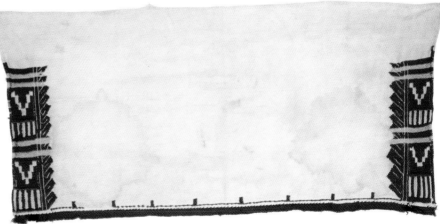

Pueblo dance kilt (probably Hopi), 19" x 40", c. 1920–40.
Commercial cotton with commercial wool embroidery,
both sides, in cloud symbols and rain emerging below.
Many Hopi kilts were made for other pueblos.

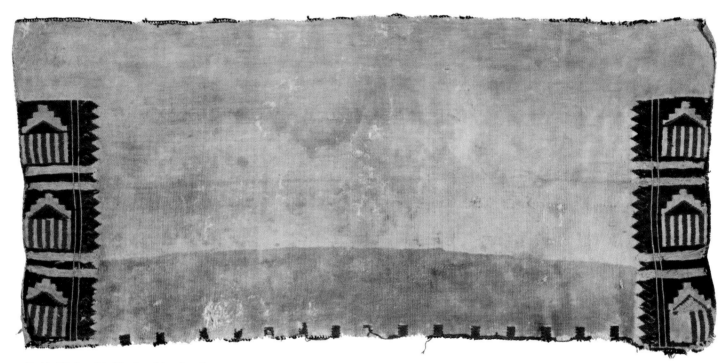

Pueblo kilt (possibly Rio Grande), 17" x 39", c. 1920–35.
Commercial wool embroidery on hand-woven cotton
cloth, in traditional symbols each end. An unusual 5" band
of turquoise blue (mineral?) paint along the bottom.

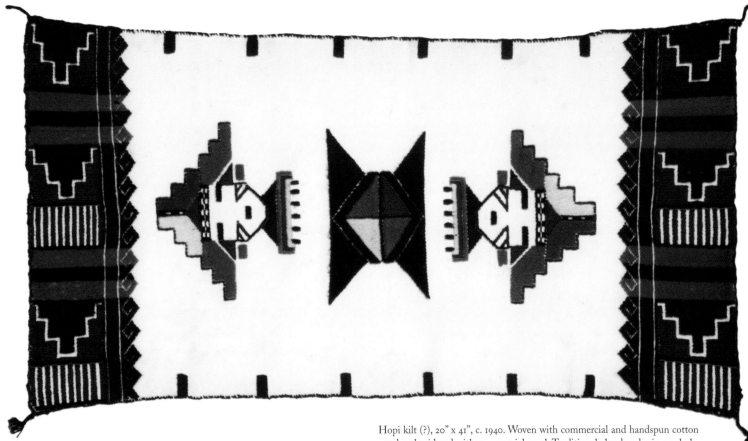

Hopi kilt (?), 20" x 41", c. 1940. Woven with commercial and handspun cotton and embroidered with commercial wool. Traditional cloud and rain symbols, both sides, with two embroidered kachina faces facing each other on either side of an unknown symbol. Note that the design elements extend completely to both ends, as opposed to the traditional design treatment.

Hopi kilt, 21" x 33", c. 1880–1920. Woven in commercial and handspun cotton, dyed blue/black with blue corn dye. Given to young boys when they began to participate in ceremonies, especially the Snake and Flute dances. The two black circles represent "blossom centers" and are painted on.

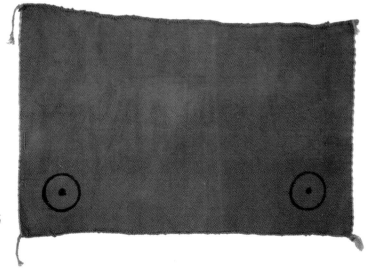

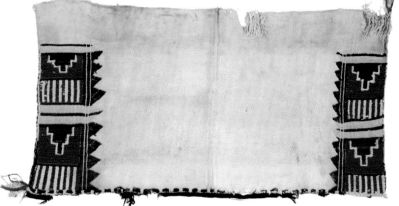

Pueblo kilt (possibly Rio Grande), 17" x 33", c. 1915–25. Woven of native handspun cotton with commercial wool embroidery on both sides and along the bottom, with red yarn possibly dyed with cochineal.

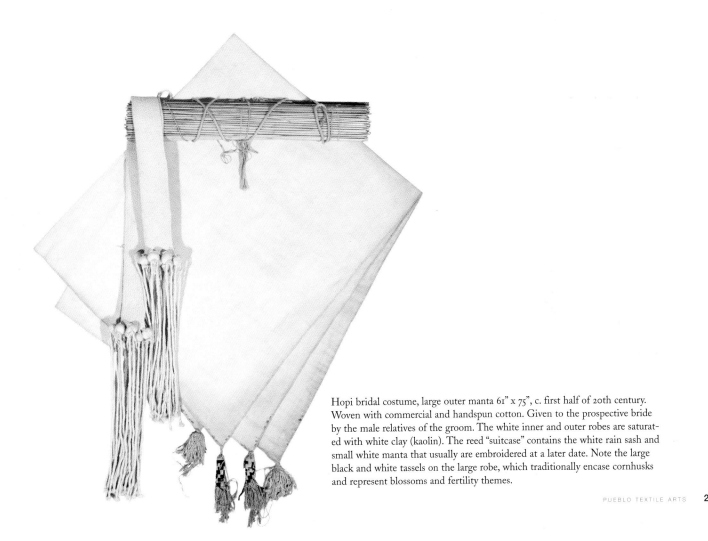

Hopi bridal costume, large outer manta 61" x 75", c. first half of 20th century. Woven with commercial and handspun cotton. Given to the prospective bride by the male relatives of the groom. The white inner and outer robes are saturated with white clay (kaolin). The reed "suitcase" contains the white rain sash and small white manta that usually are embroidered at a later date. Note the large black and white tassels on the large robe, which traditionally encase cornhusks and represent blossoms and fertility themes.

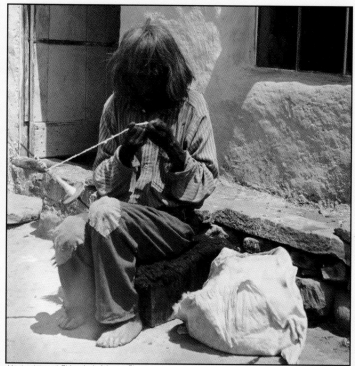

Hopi spinner at Shipaulovi, Arizona. Photographer unknown, ca. 1920. Museum of New Mexico #21545.

There are two basic types of dance sashes: the all-white cotton type, called variously a rain or wedding sash, and the brocaded cotton-and-wool sash. The white sash has a long fringe with round white balls near the body. Kate Peck Kent writes, "It is made by a process called sprang. In this method, the yarn is wound continuously around two poles, and each interlacing movement carried out at one pole repeats itself the full length of the yarn set."[3] As in all woven cotton textiles, commercial cotton string replaced handspun cotton in the late nineteenth century. These sashes were worn by dancers in almost all the Rio Grande pueblos and at the Hopi villages, and were also an integral part of the wedding outfit.

The brocaded sash, which is woven in cotton with the end panels decorated in colored wool yarns of red, green, blue (or purple), and black, were produced at many pueblos, with the Hopis the most prolific. Brocading is a weaving technique, in contrast to embroidery, which is done with a needle after the item is removed from the loom. Designs on brocaded sashes have changed very little since the late nineteenth century and have become essentially standardized. The abstract designs have been described variously as the mask of the Broadfaced Kachina, blossoms, flowers, rain, and clouds; here again, the original symbolic meanings have probably been lost in time. Occasionally a rare representational image, such as a full kachina mask or butterfly, is brocaded on a Hopi woven sash.

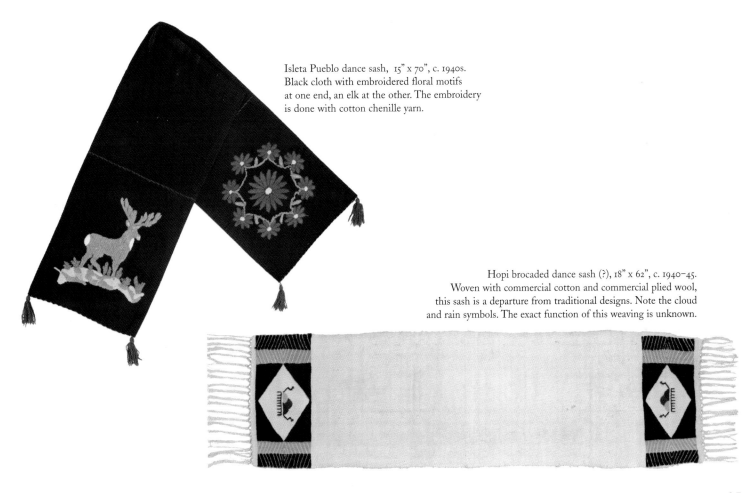

Isleta Pueblo dance sash, 15" x 70", c. 1940s.
Black cloth with embroidered floral motifs
at one end, an elk at the other. The embroidery
is done with cotton chenille yarn.

Hopi brocaded dance sash (?), 18" x 62", c. 1940-45.
Woven with commercial cotton and commercial plied wool,
this sash is a departure from traditional designs. Note the cloud
and rain symbols. The exact function of this weaving is unknown.

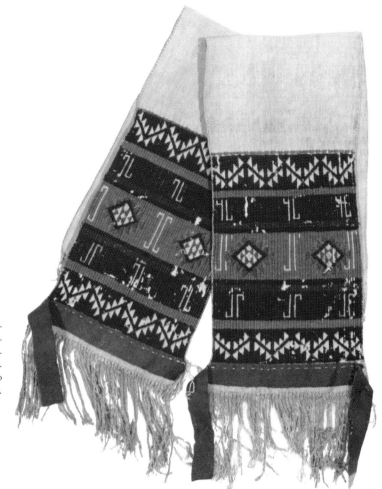

Hopi brocaded dance sash, 9" x 39", c. 1870–80.
Most side sashes use commercial wool for the designs.
This one uses native handspun wool and handspun cotton.
The blue is indigo dye, the green probably a vegetal dye.
Note the strip of trade cloth along the bottom. The two
halves are usually stitched together.

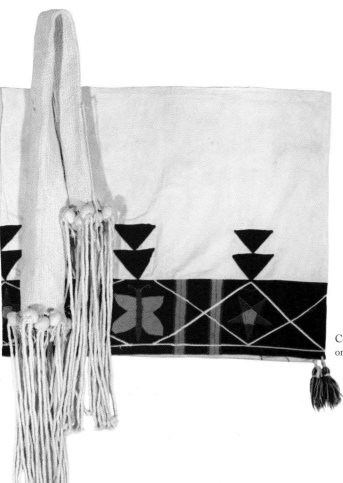

Composition of textiles pictured
on pages 16 and 25.

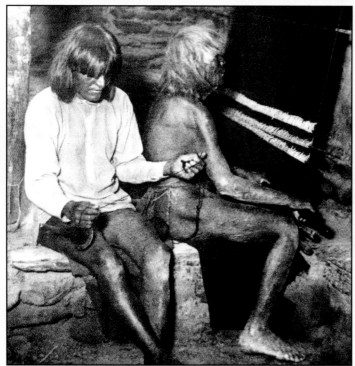

Hopi spinner and weaver in Kiva. Photograph by Jesse Hastings Bratley, ca. 1902 Smithsonian Institution NAA-53458.

Unlike Navajo dresses, which are woven in two separate panels and stitched together, Pueblo dresses are basically woolen mantas that are folded in half. They are worn under the left arm, pinned on the right shoulder, and belted at the waist. As with mantas, the end panels are usually done in diamond twill and the center in diagonal twill. Until the early 1880s, the ends were dyed with indigo and the centers were natural brown; later, dresses were dyed black.

Dress and manta weaving died out in the Rio Grande pueblos by the early 1880s but continued at the Hopi and Zuni villages. Around 1870 the Hopis began adding red and green wool piping along the bottom edge, where the end panel met the center. During a revival of this kind of weaving in the first half of the twentieth century, a few Rio Grande pueblos, especially Isleta, embroidered flowers or game animals (deer and elk) in one corner. Today, the traditional costume has become almost totally Americanized: Anglo-American clothing predominates, with the addition of fringed shawls. Traditional garments are now worn only at ceremonies and special occasions.

Zuni Pueblo woman's dress, two panels, 24" x 33", c. 1900–20. Woven in native handspun wool with a diagonal twill center panel and diamond twill end panels. The center is over-dyed in black.

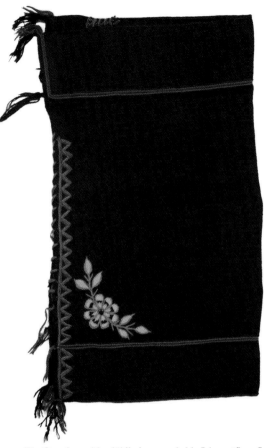

Rio Grande pueblo child's dress, probably Isleta, 18" x 32", c. 1900–1930. Woven in native handspun wool with a diagonal twill center and herringbone twill end panels, embroidered with commercial wool in a buttonhole stitch flower motif on one corner of both panels. The red and green wool embroidery on one side is unusual.

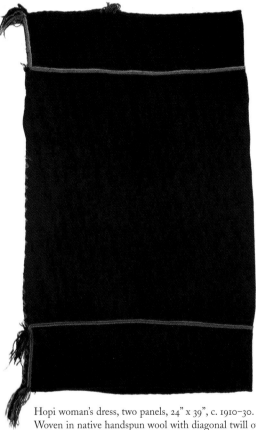

Hopi woman's dress, two panels, 24" x 39", c. 1910–30.
Woven in native handspun wool with diagonal twill over-
dyed center and diamond twill end panels with traditional
Hopi red and green wool piping.

Pueblo woman's dress, two halves, 30" x 46", c. 1920s.
Canvas sack cloth embroidered in commercial four-ply
wool in gold, orange, black, and green with sacred corn
plants and black and red-orange raven (?) symbols; sten-
ciled on the inside are the words "American Extra Heavy."
The dress is fringed and tasseled at the bottom. Probably
made at the Santa Fe Indian School.

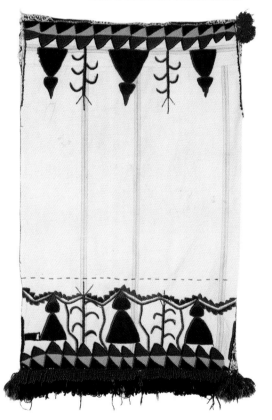

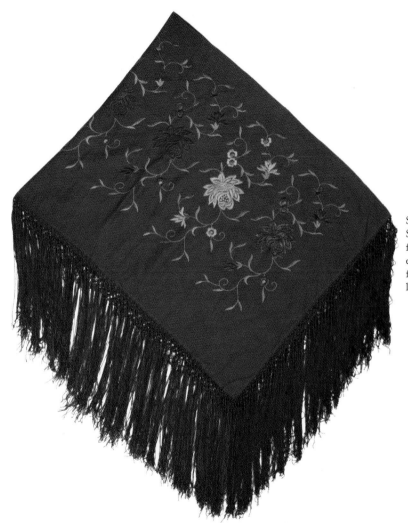

San Felipe Pueblo shawl, 67" x 57", c. 1925–45.
Silk machine-embroidered on commercial cloth,
fringe added. These Anglo-American shawls were
especially popular in the Rio Grande pueblos in the
first half of the 20th century. The women frequent-
ly added the fringe.

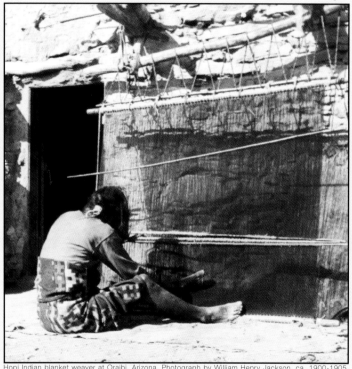

Hopi Indian blanket weaver at Oraibi, Arizona. Photograph by William Henry Jackson, ca. 1900-1905.
Colorado Historical Society #CHS.J1822.

These items are woven on a traditional backstrap loom with a warp float technique--that is, the warps are floated to create the design. Belts were woven at all the pueblos and by the Navajos; today, they are made primarily by Hopis and Navajos. Belts woven by the Hopis for their own use are red, black, and green wool. Those woven by the Hopis for sale or trade, and those woven by the Navajos, are red, white, and black. In the 1880s Germantown yarn was used, including the color purple. Hopi belts are distinguished by a continuous design running lengthwise down the center, whereas the Navajo center design is intermittent. Beginning in the 1950s, other colors occasionally were used in the few belts woven at the Rio Grande pueblos. During the Revival period (1920-1950), an increasing number of belts were woven for sale to the tourist trade.

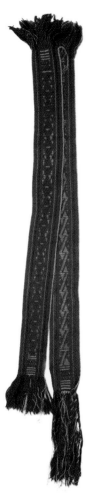

Hopi garters, 2" x 23", c. 1890–1910.
Woven in commercial plied
Germantown yarn, and typically worn
tied around the calf.

Pueblo belt, 5" x 84", age unknown (late 19th/early 20th century?).
Woven with commercial cotton and indigo blue—a very unusual design.

Nambe Pueblo belt, 2" x 40", c. post-1940.
Woven in native handspun with aniline dyes.

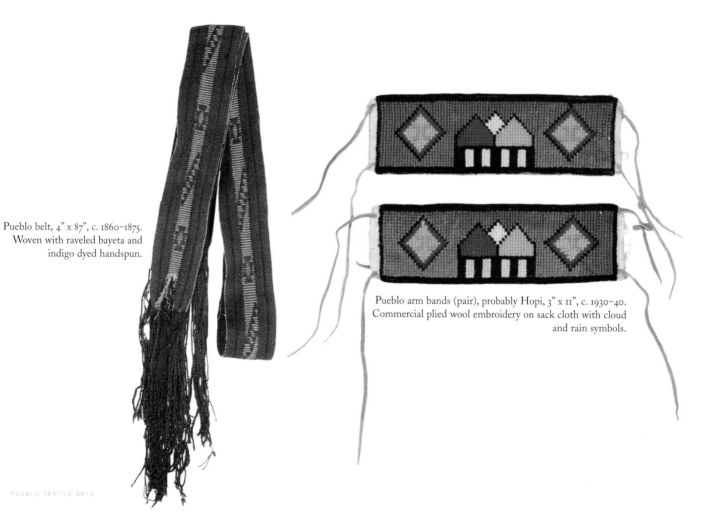

Pueblo belt, 4" x 87", c. 1860–1875.
Woven with raveled bayeta and
indigo dyed handspun.

Pueblo arm bands (pair), probably Hopi, 3" x 11", c. 1930–40.
Commercial plied wool embroidery on sack cloth with cloud
and rain symbols.

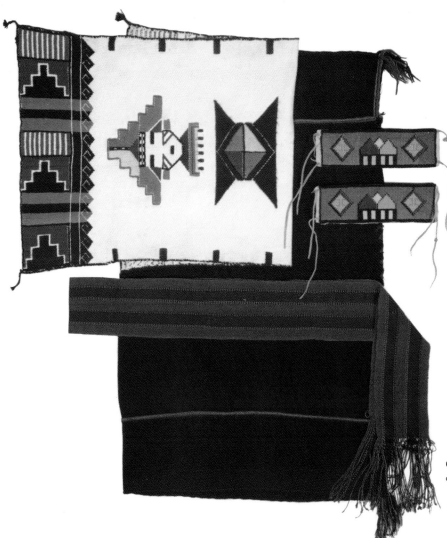

Composition of textiles pictured
on pages 23, 32, 35, and 36.

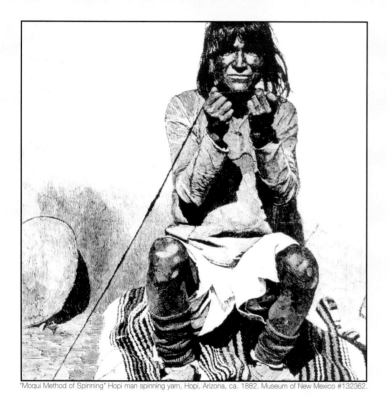

"Moqui Method of Spinning" Hopi man spinning yarn, Hopi, Arizona, ca. 1882. Museum of New Mexico #132362.

Pueblo weavers made two kinds of wool shirts and a cotton shirt that was embroidered with designs in wool yarn. The first wool type (1800–1880) was woven in a twill weave of natural dark brown wool over-dyed with indigo blue; in later periods, the shirts were dyed black. They were made in three pieces: a center rectangular panel, with a hole for the head, and two sleeves woven in an expanding triangular shape, the large end sewn or tied to the center panel at the shoulder. The second type of wool shirt was exactly like the first except for the addition of horizontal red stripes in the body. A few shirts were woven without sleeves in a poncho style.

Handspun cotton shirts, which have existed since prehistoric times, are woven in three parts. In the nineteenth century they were embroidered in wool with various symbols. Originally Acoma Pueblo was famous for embroidered shirts, but in the late nineteenth century they became a specialty at Jemez Pueblo, with wool tassels added at the ends of the sleeves and bottom of the bodice. The Hopis also embroidered cotton shirts with wool in symbolic designs.

By the beginning of the twentieth century, commercial cotton cloth had replaced handspun. During the Revival period (1920–1950), embroidered vests were made for sale to tourists, primarily at Jemez and the Hopi villages; the Santa Fe Indian School also encouraged the creation of these items. The embroidered shirts, along with the embroidered mantas and painted kilts, are some of the most aesthetically pleasing items that were made.

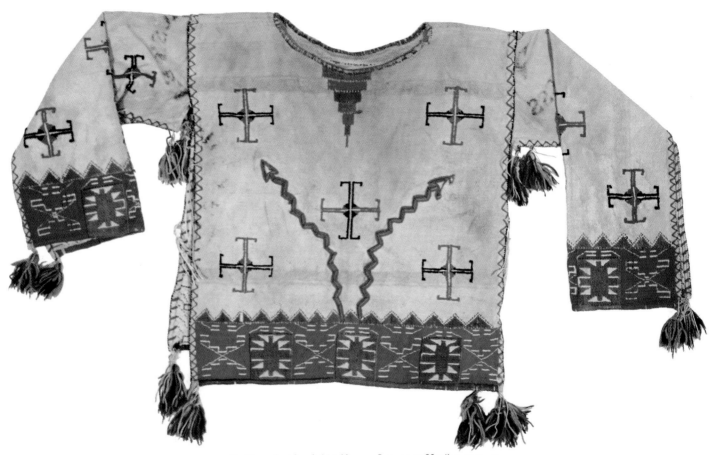

Pueblo embroidered shirt (Acoma, Laguna, or Hopi), c. 1920–40.
Commercial cotton embroidered with plied commercial wool
with various symbols, including two lightning bolts; wool tassels
on the sleeves and bottom.

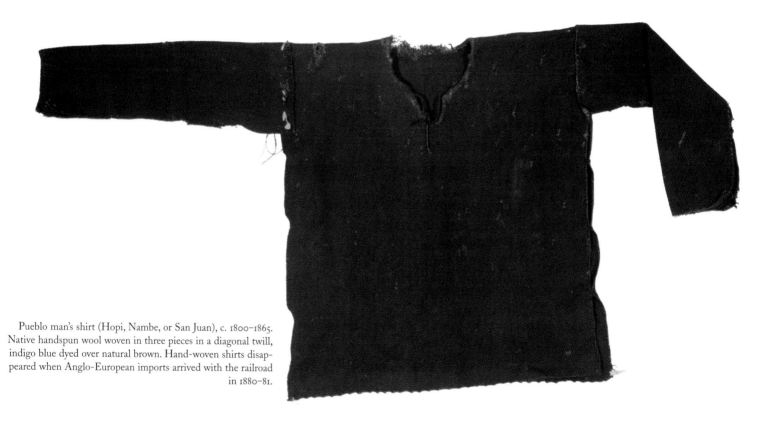

Pueblo man's shirt (Hopi, Nambe, or San Juan), c. 1800–1865. Native handspun wool woven in three pieces in a diagonal twill, indigo blue dyed over natural brown. Hand-woven shirts disappeared when Anglo-European imports arrived with the railroad in 1880–81.

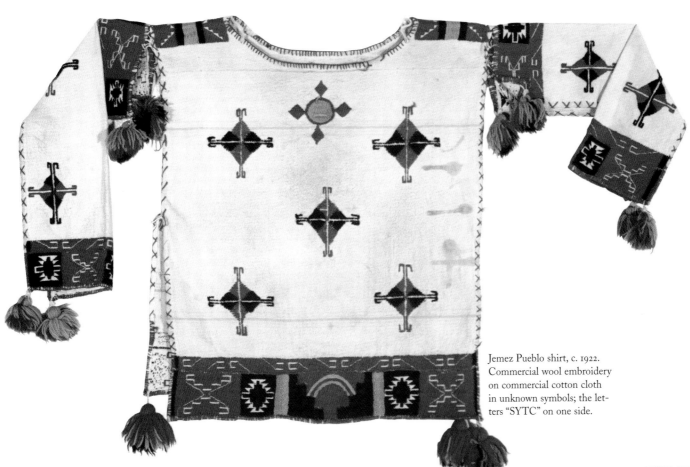

Jemez Pueblo shirt, c. 1922.
Commercial wool embroidery
on commercial cotton cloth
in unknown symbols; the let-
ters "SYTC" on one side.

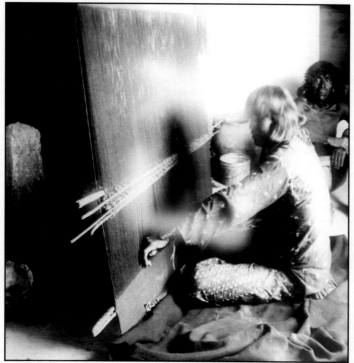

Hopi weaver at Hopi, Arizona. Photograph by Frederick Maude in 1897. Museum of New Mexico #14427.

Although the influx of tourists in the Southwest began with the coming of the railroads in the 1880s, the most significant numbers began to arrive between the two world wars and into the 1950s. This increase was greatly aided by the automobile and the construction of national highways, in particular, Route 66, which provided access to the Pueblo villages of New Mexico and Arizona and the southern boundaries of the Navajo Nation.

This increase in tourism, in turn, gave rise to an increased demand for souvenirs to be taken back home as mementos of the "wild west." Souvenir shops became ubiquitous along the major highways. The growing demand for "authentic" Indian items led, in turn, to the mass production of items that were not Indian made. Various groups and government agencies tried to counteract these trends; in the 1930s, for example, genuine Navajo silver and turquoise jewelry was stamped with the words "U.S. Navajo." A good case could be made that this increased interest and demand led to the ever-increasing production and flowering of Pueblo pottery.

During the same period, efforts were made to revive the skills and production of Pueblo textiles and to capture some of the commercial market so long dominated by Navajo weavers. Foremost among the leaders of this effort was the Santa Fe Indian School, which taught students the old art of embroidery. Although the weaving of handspun cotton cloth had virtually disappeared among Pueblo weavers, inexpensive commercial cloth was readily available.

One result of these endeavors was the production of items that had not been part of the traditional repertoire. Aimed specifically at the new Anglo-American tourist trade, these new items included pillow faces, placemats, table and bureau runners, and an occasional church altar cloth. Some items had no apparent function, but a significant number of all these types contained various mythological symbols, especially Hopi symbols, such as kachina masks, rain, cloud, and lightning symbols, and thunderbirds and eagles. This "revival" period lasted only two or three decades, and surprisingly few examples have survived.

Notes

1. Kate Peck Kent (1978:9)
2. H. P. Mera (1975:4)
3. Kate Peck Kent (1978:82)

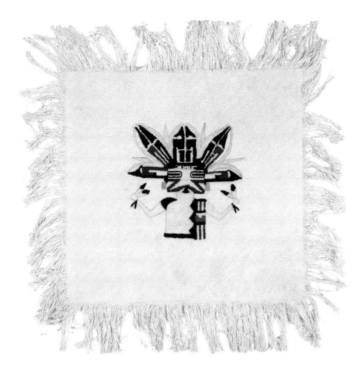

Hopi pillow face, 14" x 15", c. 1930–40.
Commercial cotton cloth backed with
satin, embroidered with commercial
wool with a likeness of Polik Mana kachina.
A delightful tourist souvenir.

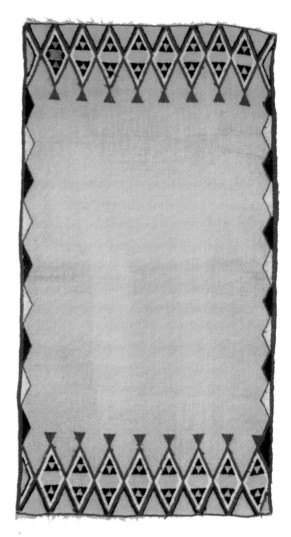

Pueblo textile, 25" x 47", c. mid-20th century.
Commercial wool embroidery on handspun cot-
ton woven on a non-Pueblo loom. Possibly an
altar cloth or table runner.

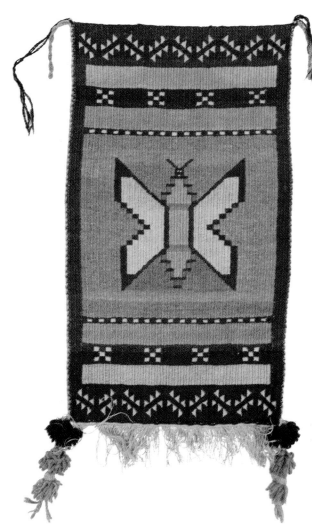

Hopi place mat, 14" diameter, c. 1920s–40s. Embroidered with commercial wool in Pueblo stitch, aniline dyed with a Polik Mana kachina mask on cloth. Made to resemble a woven wicker plaque from Third Mesa. A tourist item that was probably made at the Santa Fe Indian School.

Pueblo textile, probably Hopi, function unknown, 13" x 24", c. 1920–30. Woven with native handspun wool with a small amount of commercial wool, in the wrapped brocade technique.

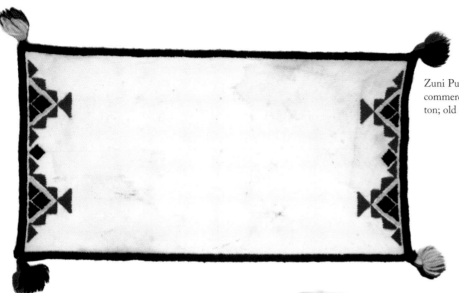

Zuni Pueblo altar cloth, 9" x 18", c. 1940, commercial wool embroidery on commercial cotton; old attached tag reads "Zuni Church Cloth."

Pueblo cloth (altar cloth or table runner?), 14" x 30", c. 1930–40. Commercial wool embroidery on commercial wool cloth. The end panels were done separately and stitched together; an unknown symbol with lightning bolts in black.

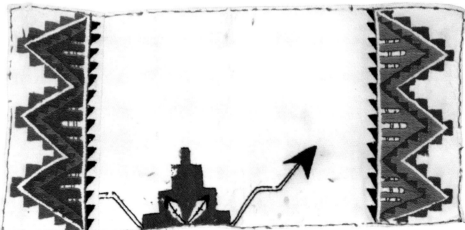

Hopi/Pueblo leggings, early 20th century.
Crochet with commercial plied cotton. Prehistoric
foot and leg coverings were woven with a finger
weave technique. It is generally accepted that the
Spanish taught the Pueblos to crochet.

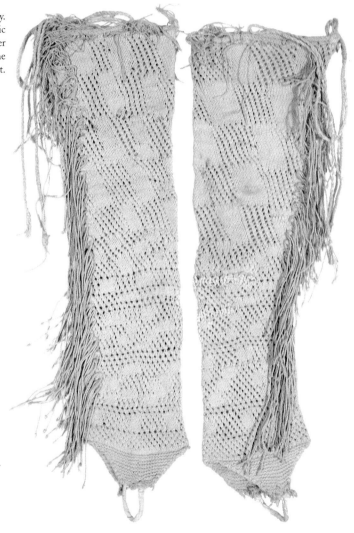

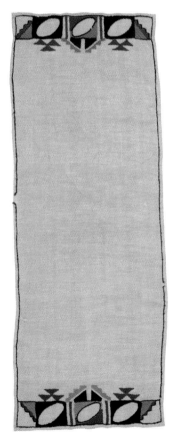

Santa Clara Pueblo table runner, 16" x 44", c. 1930.
Tag: "from the estate of Lucy Prior, Santa Clara
Pueblo done by Indian School (Santa Fe)."

Bibliography

Douglas, Frederic H. Indian Leaflet Series, Nos. 4, 89, 90, 91, 92–95, 94-95, 96-97. Denver: Denver Art Museum, 1939–1940.

Fox, Nancy. *Pueblo Weaving and Textile Arts*. Santa Fe: Museum of New Mexico Press, 1978.

Kent, Kate Peck. *Pueblo Indian Textiles*. Santa Fe: School of American Research Press, 1978.

Mera, H. P. *Pueblo Indian Embroidery*. Santa Fe: William Gannon, 1975.

Sando, Joe S. *Pueblo Nations*. Santa Fe: Clear Light Publishers, 1992.

Underhill, Ruth. *Pueblo Crafts*. Washington, DC: US Department of the Interior, 1944.

Whitaker, Kathleen. *Southwest Textiles*. Seattle: University of Washington Press, 2002.

Wright, Barton. *Hopi Material Culture*. Flagstaff: Northland Press, 1979.

Acknowledgments

I am particularly thankful to the Museum of Indian Arts and Culture and its Director, Duane Anderson, for the vision and foresight to mount what I believe is the first major comprehensive museum exhibition of Pueblo textiles ever undertaken. Both the Museum and I are greatly indebted to Charles Brunacini, who graciously allowed us to choose rare and important examples from his extensive collection, thirty years in the making. Marian Rodee collaborated on the project and wrote the Introduction. Blair Clark photographed the collection, Jo Ann Baldinger served as editor, and Mike Larkin designed the catalog and ushered it through the printing process.

I am grateful to a number of individuals for their assistance in financing the catalog and the exhibition. Included are Joe and Sara Alexanian, Ruth K. Belikove, Lillian Black, Elizabeth Dichter, Edwin L. Foutz, H. Malcolm Grimmer, Jeffery H. and Maurine Kahn, Rex A. and Patricia Lucke, Dennis and Janis Lyon, Thomas Melancon, Al R. Packard, Greg and Cathy Serena, David M. Stock, Bernard Ewell, Mr. And Mrs. Richard Gates, Mike Kokin, and Andrew Nagen. Major funding for the project was also received from the MIAC RainMakers, a support group for the Museum of Indian Arts and Culture through the Museum of New Mexico Foundation.

A number of individuals assisted with the catalog and exhibit, including Museum of Indian Arts & Culture staff members Dennis Culver, Valerie Verzuh, John Torres, Antonio Chavarria, Anita McNeece, David McNeece, Doug Patinka, and Joyce Begay-Foss. Invaluable assistance was provided by members of the Museum of New Mexico Exhibitions Department including Barbara Hagood, Antoine Leriche; and Susan Hyde-Holmes. Claire Munzenrider, Mina Thompson, and Debbie Juchem assisted with the conservation of items in the exhibition. John Stafford and Carole Anderson, Museum of New Mexico Foundation, and Anna Gallegos and Mary Wachs, Museum of New Mexico Press, assisted with distribution of the catalog.

Historic photographs were provided by the Colorado Historical Society, the Museum of New Mexico Photo Archives, and the National Anthropological Archives, Smithsonian Institution.

Finally, sincere thanks to Lillian Black, whose constant encouragement kept me focused on this important project.

Enjoy!

Tyrone D. Campbell
Guest Curator
Scottsdale, Arizona